THE APERTURE HISTORY OF PHOTOGRAPHY SERIES

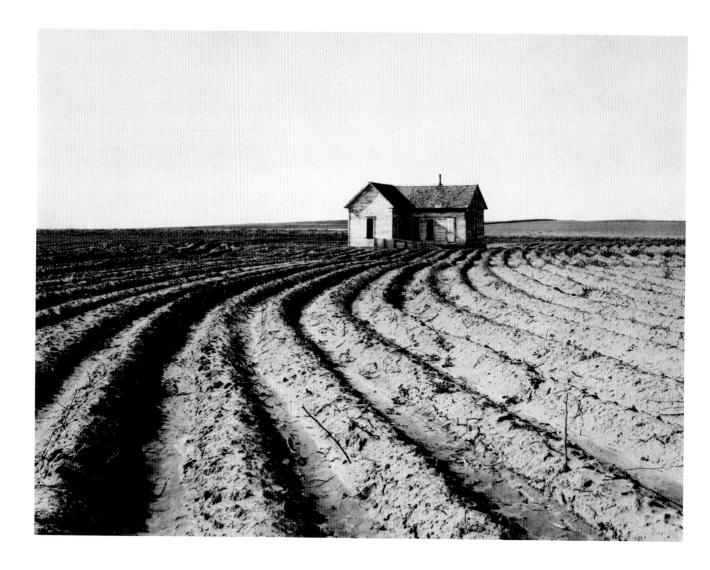

Dorothea Lange

APERTURE

The History of Photography Series is produced by
Aperture, Inc. The photographs that appear on pages 2,
19–25, 29–39, 43–49, 53–55, 59–67, 71–77 are re-
produced courtesy of The Library of Congress. Those
appearing on pages 13–17, 51, 57, 79–93 are from the
Dorothea Lange Collection, The Oakland Museum,
Oakland, California. Pages 27, 41, and 69 are
from the Shirley C. Burden Collection.

Aperture, Inc., publishes a periodical, portfolios, and
books to communicate with serious photographers and
creative people everywhere. A complete catalogue will
be mailed upon request. Address: Millerton,
New York 12546.

Dorothea Lange lived instinctively, but she always found herself in the right place at the right time. She was a maverick. She never adopted a popular style, joined a movement, or worried—like most photographers of her generation—about the technique and purity of the photographic process. Lange photographed spontaneously and often under difficult conditions. She helped us learn a great deal about ourselves in those inspired split seconds of photographing "things as they are," because she possessed the gift of inquiry. As Paul Strand said, "If the photographer is not a discoverer, he is not an artist. You must always see deeply into the reality of the world, like a Cezanne, or . . . Dorothea Lange."

During the Depression, Lange photographed in almost every state of the union and her images are imprinted on the mind of a nation: an abandoned farmhouse in a sea of tractor furrows (page 2); a hoe cutter in Alabama (page 37); a damaged, haunted-eyed child in Oklahoma (page 57); an ex-slave "with a long memory"; a migrant mother surrounded by her hungry children (page 39). Lange photographed the *essence* of social and economic experience—customs, work, and play. She also captured the even more intangible *presence* of institutions—church, government, family, political organizations, and labor unions. Lange, inci-

dentally, disliked the label "documentary" applied to her work, but she never found a word she liked better. The question, she insisted, was less a matter of subject than of approach: "The important thing is not what's photographed but how." She kept the following quotation from Francis Bacon pinned to her darkroom door: "The contemplation of things as they are, without error or confusion, without substitution or imposture, is in itself a nobler thing than a whole harvest of invention."

Born in Hoboken, New Jersey, in 1895, Lange was raised by her mother on the Lower East Side of New York City. Her father abandoned the family when she was a child, and soon after his departure she contracted polio, which left her with a lifelong limp. She saw herself as an outsider. Her life seemed to pass between school and the public library where her mother worked. In midafternoon she would join her mother, presumably to study; instead she sat in the windows and watched the busy lives of Jewish immigrant families in neighboring tenements. Even then, as Lange later remarked, she was "acting like a photographic observer." She could recall her child's eye focused on significant details of Saint Bartholomew's Church on Park Avenue, in particular the expressive hands of the choirmaster. She taught herself to spy inconspicuously. Walking home alone at night

along the Bowery, she adopted an expressionless mask, a "cloak of invisibility" that she cultivated to good use later.

After graduating from high school Lange studied to be a teacher, then abruptly announced to her mother that she had decided to be a photographer. She chose the profession, she later said, simply "as a way to maintain myself on the planet." Yet, she had no camera and had never made a picture. Walking along Fifth Avenue one day, Lange was struck by the portraits displayed in the window of Arnold Genthe's fashionable studio. She walked inside and asked for a job. During the years leading up to World War I, Lange assisted Genthe in the darkroom and also worked as a receptionist. She found him to be a lecherous soul, but she also recognized him as a great photographer of women. "I found out there that you can photograph what you are really involved with," she recalled. Genthe "loved women. He understood them. He could make the plainest woman an illuminated woman."

Previously, Genthe had photographed San Francisco's Chinatown and the aftermath of the 1906 earthquake. But his best work was behind him. He fancied himself as an innovator of the "candid" portrait. Younger critics, however, decried the soft-focus Pictorialist haze that infused Genthe's studies.

Chief among the photographers struggling to overturn this Romantic style of imitation paintings were New York avant-gardists such as Clarence H. White, Edward Steichen, Gertrude Käsebier, and Alfred Stieglitz. They were among the founders of the Photo-Secession movement—

dedicated to shunning print manipulation in favor of straightforward, unfrilled images. Soon, Lange was attending White's seminars at Columbia University, finding in his work a "poetry and luminosity" she had not seen before.

"Why he was extraordinary has puzzled me ever since," Lange recalled, "because he didn't do anything. I don't think he mentioned technique once, how it's done, or shortcuts, or photographic manipulations. It was to him a natural instrument. I suppose he approached it something like a musical instrument which you do the best you can with when it's in your hands."

When the course ended, Lange bought a large camera and two lenses and began to work in earnest by herself. Her subjects were relatives and friends. The prints emerged from a backyard chicken coop that she converted into a darkroom.

Lange always insisted that her decisions were instinctive. In 1918, at the age of twenty-two, she followed those religiously trusted instincts and left New York with a close friend to travel around the world. The tour was abruptly interrupted in San Francisco when the two women were robbed of their traveling funds. Lange started work in the photo-finishing department of a dry-goods store. Among her new acquaintances were the photographer Imogen Cunningham and her husband Roi Partridge. To gain access to a darkroom, Lange joined the San Francisco Camera Club, where she met a wealthy young man named Jack Boumphrey, who offered to finance her in opening her own portrait studio.

One year after arriving in San Francisco, Lange opened the studio, which was an immediate suc-

cess. She became the favored photographer of a circle of wealthy families who had settled in the Bay Area during the Gold Rush and become leaders of the city's civic and cultural life. "That place was my life," Lange said, "and it was the center for many others." Each afternoon at four, Lange lit an old brass samovar, and friends and clients began to drop in. She greeted them in bobbed hair, sandals, and a Fortuny gown, while a Chinese-American maid and photographer's assistant served tea and shortbread.

All of Lange's work was commissioned, and most of her photographs commemorated major family events. In the studio, she usually kept a respectful distance from her subjects. But when she took her camera into their homes, her work exhibited more spontaneity. She followed children into backyards and posed family members against blossoming trees, hanging vines, or sun-lashed walls. In one of her most moving photographs, she captured the tender gesture of a mother leaning over to kiss her sleeping child in a room obscured by shadows. Lange mounted her prints on hand-made Japanese paper with a deckle edge and signed them in a hand that became increasingly illegible every year. Although these portraits contain hints of her later documentary work, particularly in her understanding of the qualities and uses of light, Lange's commercial portrait work is fairly conventional. She labored to establish herself as a successful tradeswoman whose task was to please her clients.

There is a timelessness in these pictures that Lange later rejected. "I used to try to talk people into having their pictures taken in their old, simple clothes," she said. "I thought if they did, the images would be timeless and undated. Now I feel I was mistaken and think that to have any significance, most photographs have *got* to be dated. . . . Everything is shut out of many prints but the head—there's no background, no sense of place." Imogen Cunningham characterized those pictures as "softened portraiture. Beautiful. But not what the people were really like."

In 1920 Lange married the painter Maynard Dixon, whom she had met through Roi Partridge, and in 1925 and 1928 she bore her two sons. Marriage did not immediately alter her career. Dixon painted western scenes, and he was often away on sketching trips. Lange continued to make portraits in order to free him for his work and at the same time to keep the family fed and clothed.

When a local reporter interviewed her as Dixon's "silent partner," he asked how an artist could be married to another artist. "Simple," she said. "Simple, that is, when an artist's wife accepts the fact that she has to contend with many things other wives do not. She must first realize that her husband does not work solely to provide for his family. He works for the sake of his work—because of an inner necessity. To do both of these things successfully, he needs a certain amount of freedom— freedom from the petty, personal things of life. An artist's work is great only as it approaches the impersonal. As Maynard's wife, it is my chief job to see that his life does not become too involved— that he has a clear field."

During the 1920s, Lange began to follow newly developing artistic instincts. While vacationing with Dixon and the boys in Arizona and northern

California, she began a series of photographs of her family that combined conventional soft-focus with the spontaneity of the snapshot. "You were able to sense, if not see," she later remarked, "more about the subjects than just faces."

Influenced in part by Imogen Cunningham's work, she also tried to photograph plant forms and landscapes, but the results did not satisfy her. Lange suffered a depression at this time. Then one day, while walking alone in the mountains, she was caught in a violent storm. "When it broke, there I was, sitting on a big rock—and right in the middle of it, with the thunder bursting and the wind whistling, it came to me that what I had to do was to take pictures and concentrate upon people, only people, all kinds of people, people who paid me and people who didn't." She knew roughly what she wanted to do; she did not yet know how to go about it.

On a visit to Taos, New Mexico, in 1929, Lange watched the photographer Paul Strand driving a truck down the road each morning and evening. He was so methodical and intent that he seldom seemed aware of her, although she watched him nearly every day for seven months. She was profoundly moved by this glimpse of a photographer and artist dominated by "private purposes he was pursuing."

Two months after Lange returned to San Francisco the stock market crashed. She continued to make portraits for the few people who could still afford them, but the pattern of her life had been broken. To save money, she and Dixon moved into their respective studios and boarded the boys at schools.

It was an extremely difficult time emotionally for Lange, but it forced her to open herself to new subject matter. From her studio windows she could observe the erratic, drifting flow of street life. "One morning, as I was making a proof at the south window, I watched an unemployed young workman coming up the street. He came to the corner, stopped and stood there a little while. Behind him were the waterfront and the wholesale districts; to his left was the financial district; ahead was Chinatown and the Hall of Justice; to his right were the flophouses and the Barbary Coast. What was he to do? Which way was he to go?"

Lange recalled that stormy day in the mountains and suddenly felt the need to leave her studio and photograph the reality moving about the streets. Had her life not been shaken up, "if the boys had not been taken from me by circumstances, I might have said to myself, 'I *would* do this, but I can't because. . . .' I was driven by the fact that I was under personal turmoil to do something." . . . "I knew," she added, "[that] I'd better make this happen."

In 1933, the worst year of the Depression, fourteen million people were out of work, and many of the unemployed drifted aimlessly, living on the streets. Near Lange's studio, a wealthy woman known as the "White Angel" had set up a breadline. Wandering through the crowd, Lange made several shots including two of a man in tattered clothing leaning against a barricade with his hands clasped. She then returned to her studio to develop the film. The next day, while emptying the holder in the darkroom, her assistant found and developed an exposure she had missed. Lange called it

White Angel Breadline (page 13). When she hung it on her studio wall her friends and clients asked what she intended to do with it. Lange said she had no idea. Later it became one of the most famous photographs of the Depression.

Lange began to leave her studio with a vengeance—photographing the maritime strikes on the waterfront, the May Day Demonstrations of 1933, men on relief doing pick-and-shovel work, and the armies of transients who shuffled in breadlines or slept outside unemployment offices. She moved in close for the intimate reflections of economic collapse: a woman's legs sheathed in mended stockings, for instance, or a pair of ruined shoes. Of one forlorn man she said, "Five years earlier, I would have thought it enough to take a picture of a man, no more. . . . I wanted to take a picture of a man as he stood in his world—in this case, a man with his head down, with his back against the wall, with his livelihood, like the wheelbarrow, overturned."

With the possible exceptions of Lewis Hine and Jacob Riis, who made studies of workers and slum conditions in New York in the 1890s and early 1900s, there were no precedents in America for the kind of photographs Lange now started to make. She instinctively joined a cultural movement to reveal the impact of economic and social changes in the lives of the American people. New forms of realistic expression in art and literature, film and photography were emerging—with Lange in its vanguard of documentary in the 1930s.

In 1934 the photographer Willard Van Dyke gave Lange her first show at his gallery in Oakland, California. The exhibition led to her meeting Paul Taylor, an associate professor of economics at Berkeley who believed that photography was a potentially powerful research tool for the social sciences. He was immediately struck by Lange's work, particularly by an image of a speaker at the microphone during the San Francisco general strike, and he used the picture to illustrate an article he had written. A year later, when he became director of the California Rural Rehabilitation Administration, he enlisted Lange's services. She photographed the first migrant workers who flooded California after the Oklahoma dust storms, the camps that began to line the highways, and the pea pickers of Nipomo. She and Taylor interviewed her subjects and combined words with photographs to create compelling social essays. The reports were designed to effect change, and they did: the government responded with money and programs.

That same year Lange and Dixon divorced. She married Taylor soon afterward, closed her portrait studio, and began to devote all her energies to the new work. Between 1935 and 1939 she worked as a photographer for the Farm Securities Administration, which had been formed to bring assistance to the poor and unemployed—in part by bringing the gravity of their situations before the public. Roy Stryker, who headed the program, allowed his photographers independence. After briefing them on the economic and sociological problems they were to photograph, Stryker encouraged them to interpret these stricken lives with artistry, drama, and compassion.

Lange's procedure on field trips was purposely not to plan the route in detail. She simply started

out in an approved direction and drove until she saw something worth looking into. Preconceived ideas, in her case, minimized chances of success. Willard Van Dyke wrote in *Camera Craft:* "Her method is to eradicate from her mind before she starts, all ideas which she might hold regarding the situation—her mind like an unexposed film."

At her most potent, Lange astounds with an ability to arouse deep feelings about our commonality with others. She made her FSA photographs artlessly personal by engaging people in conversation while moving naturally among them. She could, when she wanted to, don the cloak of invisibility of her childhood, and wander through migrant camps unnoticed. More often she would sit with someone and swap stories and photograph, then return to her car to write down her informants' tales for the FSA records. She wanted intimate records that would encourage humane solutions to social problems. "If you see mainly human misery in my photographs," she said, "I have failed to show the multiform pattern of which it is a reflection. For the havoc before your eyes is the result of both natural and social forces."

Her photograph *Migrant Mother* (page 39) became an icon of the thirties. Lange was returning from her first FSA field trip when she passed a pea pickers' camp. Twenty miles down the road she decided to turn back to it. When she got there, she saw the woman immediately, sitting in her rundown tent with her children. The woman was thirty-two and the mother of seven. She told Lange that they were living on wild birds caught by the children. The pea crop had frozen on the vines, and there was no work. But she could not move on; she had sold the tires from her car for food. Lange spent only ten minutes with the woman, but the photographs she took captured the attention of the entire country.

In an introductory essay for the Lange retrospective exhibition in 1966 at The Museum of Modern Art in New York, George P. Elliott wrote: "This picture, like a few others of a few other photographers, leads a life of its own. That is, it is widely accepted as a work of art with its own message rather than its maker's; far more people know the picture than know who made it. There is a sense in which a photographer's apotheosis is to become as anonymous as his camera. For an artist like Dorothea Lange who does not primarily aim to make photographs that are ends in themselves, the making of a great, perfect anonymous image is a trick of grace, about which she can do little beyond making herself available for that gift of grace. For what she most wants is to see this subject here and now in such a way as to say something about the world."

When their work with the FSA was finished, Lange and Taylor collaborated on *An American Exodus,* a book combining the photographs and texts of their field work. But the book met with little success when it was published in 1939. America was losing interest in the Depression, turning its attention to war. During World War II Lange photographed the relocation of Japanese Americans in internment camps for the government; the pictures were not officially released until 1972. As the war ended, Lange covered the found-

ing of the United Nations in San Francisco, but her work was interrupted by the first of many illnesses. Poor health kept her from concentrated photography for the next nine years.

In 1958 Paul Taylor, now a consulting economist for government agencies and private foundations, was offered a chance to travel. As an expert in community development, he advised officials in low income countries about sanitation, health, family planning, agriculture, and political institutions. Lange traveled with Taylor to South America, Asia, North Africa, and Europe. Near Panmunjom she photographed three generations of a family planting onions. She took street scenes in Saigon. In Bali, she concentrated on the legs, feet and hands of dancers (page 87). In Korea, she made a series showing the eyes of Korean children and focused her camera on a single pair of slippers outside a door. "The pageant is vast," she wrote to a friend, "and I clutch at tiny details, inadequate."

In the sixties her focus shifted to the "secret places of the heart" and to "the close at hand"— the sunlit oaks that arched over her home in Berkeley (page 83), a grandson racing through the garden, a daughter-in-law whose husband has just asked for a divorce, a son embracing his first child, her husband's hands on his briefcase and umbrella. Although Lange was photographing intimate subjects, she cultivated a kind of detachment. "That frame of mind that you need to make a very fine picture of a very wonderful thing, is different from the frame of mind of being on the pavements, jostled and pushed and circulating and rubbing against people with no identity. You cannot do it by not being lost yourself."

During the last years of her life Lange was obsessed by her work. Had it not been for her family, she would have liked "to photograph constantly, every conscious hour, and assemble a record of everything to which I have a direct response. . . . I'd like to take a year, almost ask it of myself, 'Could I have one year?' Just one, when I would not have to take into account anything but my own inner demands."

In 1965 Lange discovered that she had an inoperable cancer, and she put all else aside to concentrate on assembling a retrospective exhibition of her photographs, to open at The Museum of Modern Art a year later. After sorting through forty-one years of her negatives she concluded, "A photographer's files are in a sense his autobiography. More resides there than he is aware of. Documentation does not necessarily depend upon conscious themes. It can grow of itself, depending upon the photographer's instincts. and interests."

She had once said that she could not judge a photographer's work until she had seen it in its entirety; only then could she understand the whole person. Seeing her own work in its entirety she seems to have found completion in herself both as a person and as an artist. A few days before she died she saw the first exhibition prints for the retrospective. In her last moments of consciousness she exclaimed, "This is the right time. Isn't it a miracle that it comes at the right time."

Christopher Cox

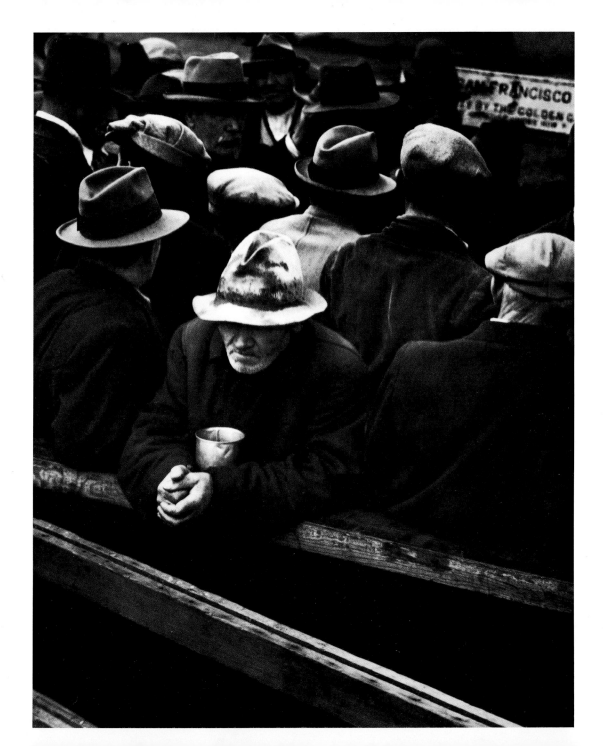

13

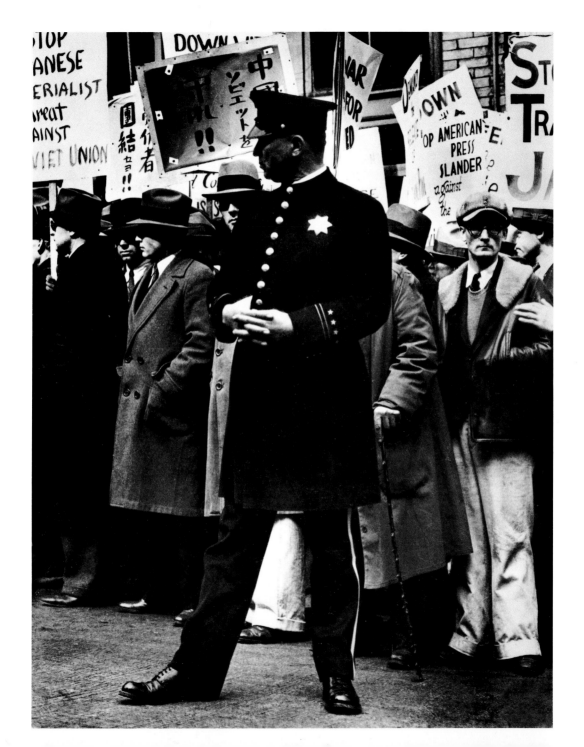

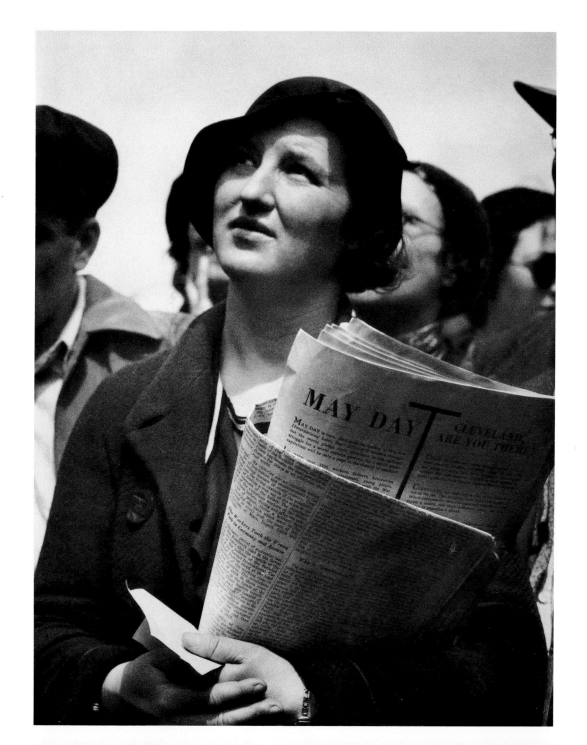

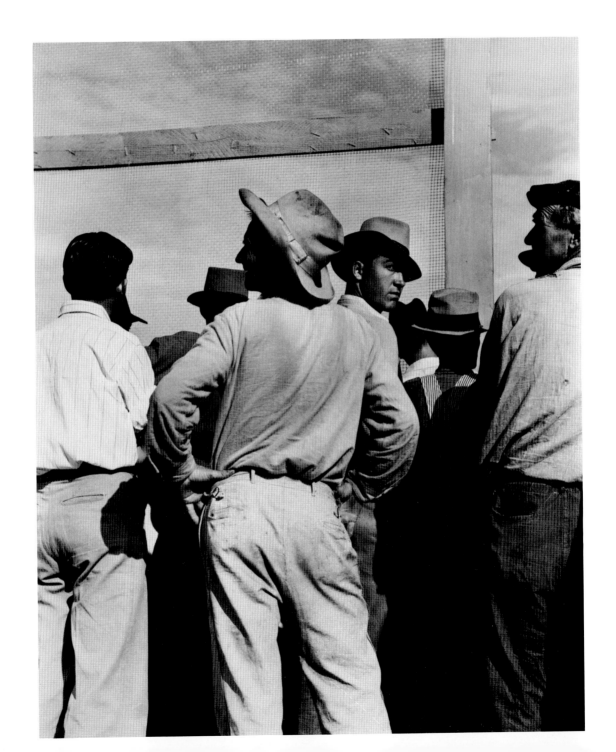

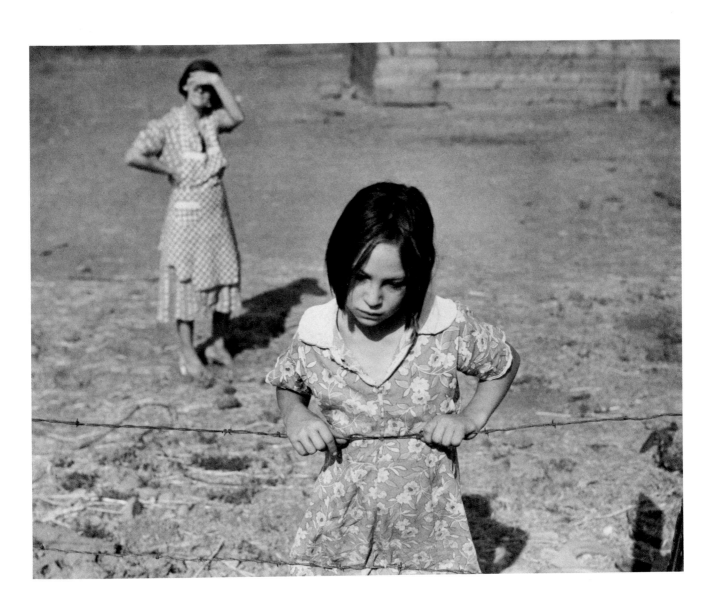

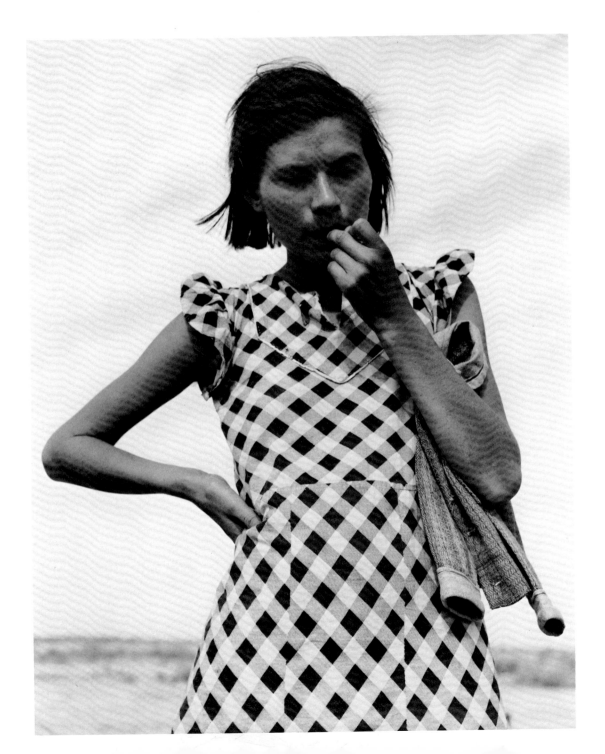

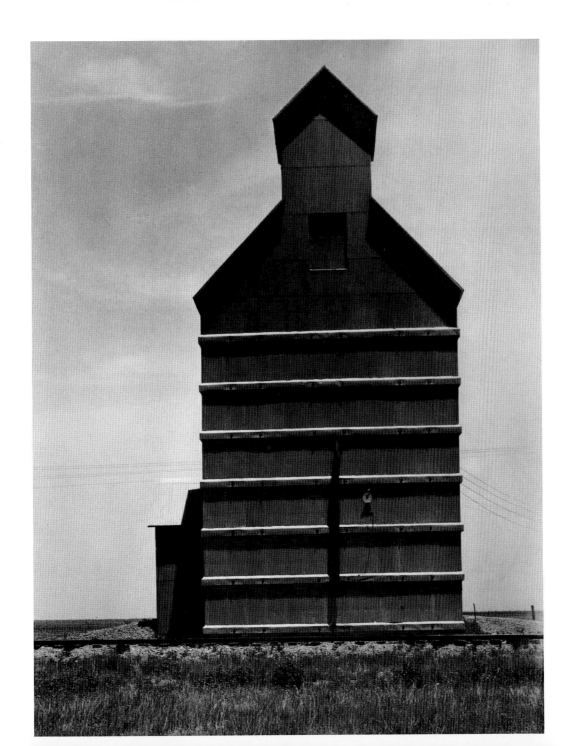

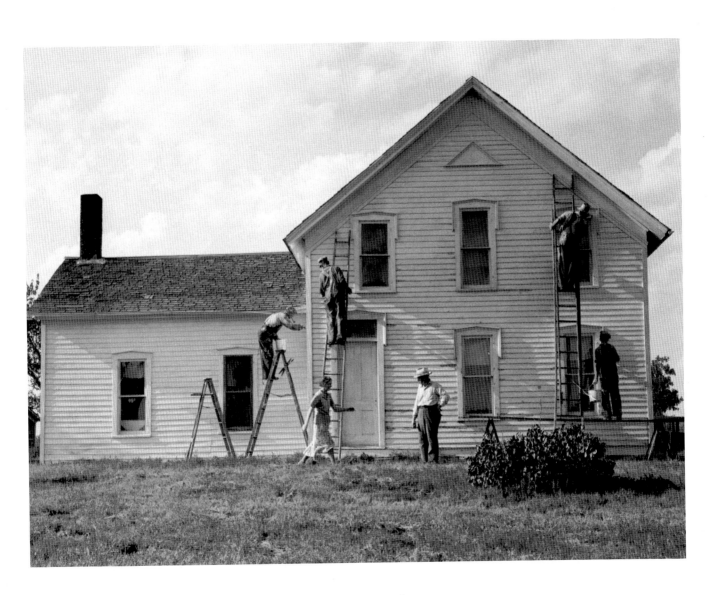

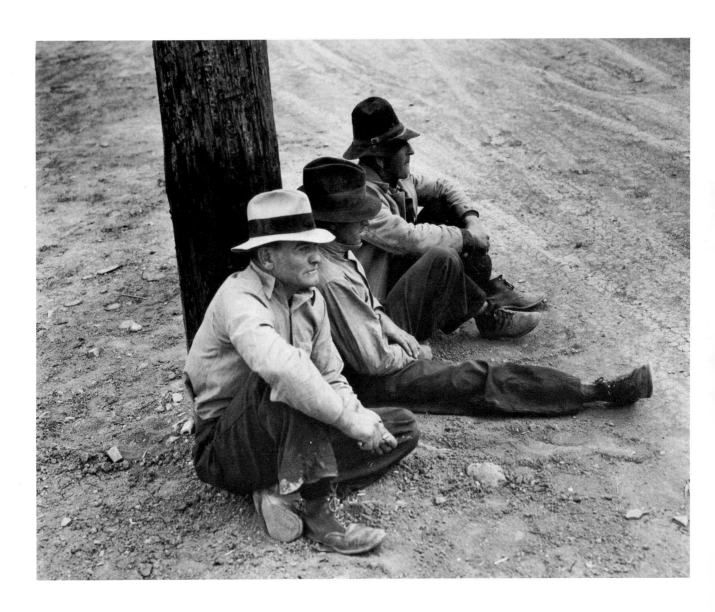

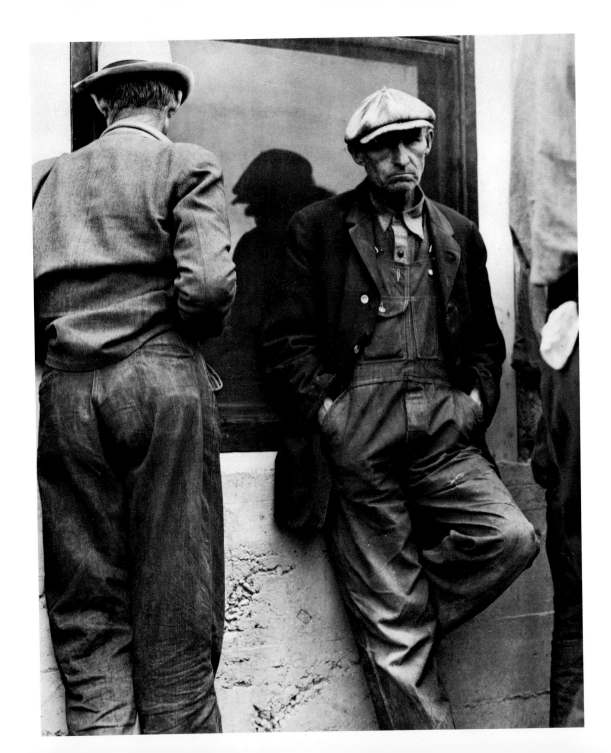

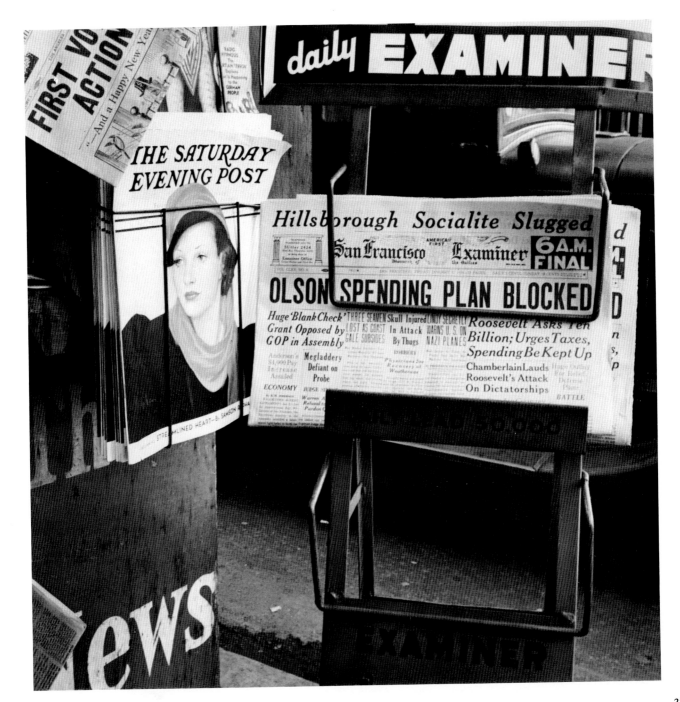

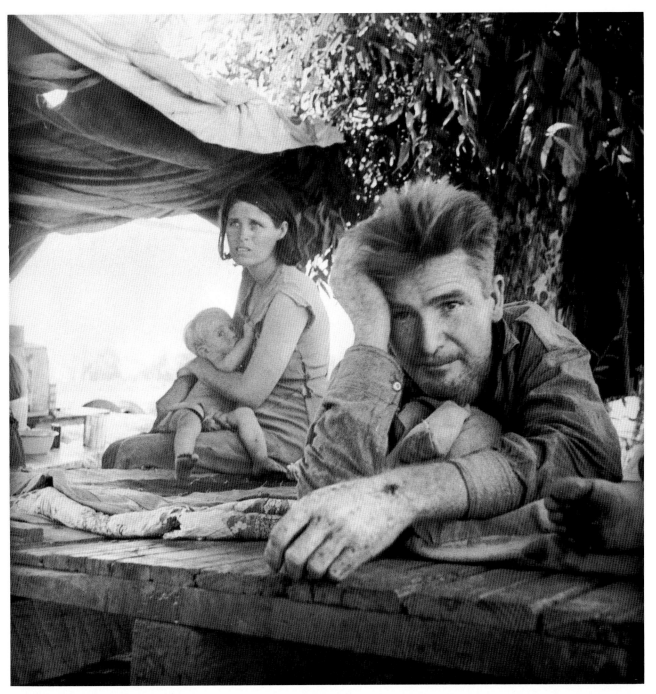

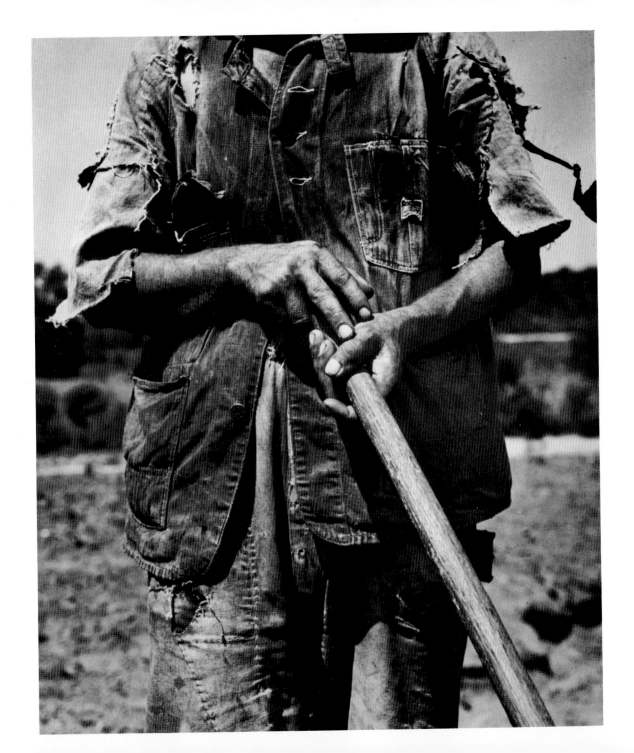

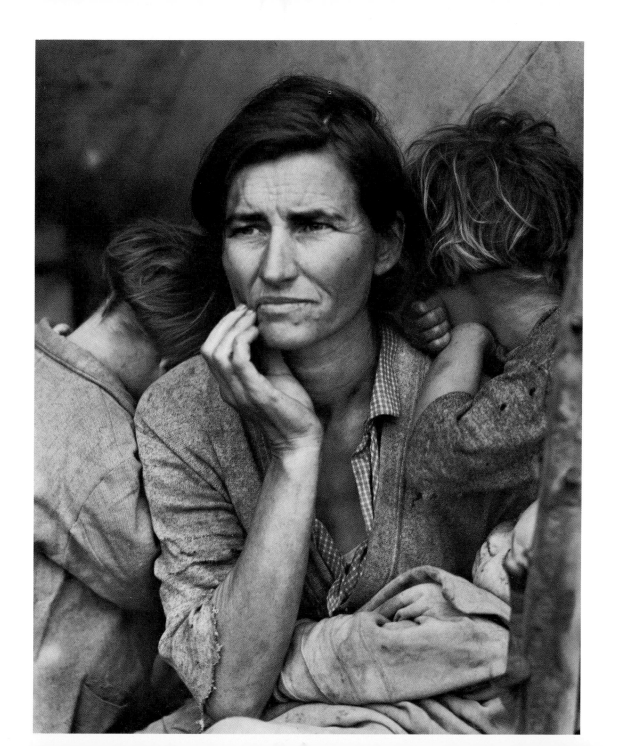

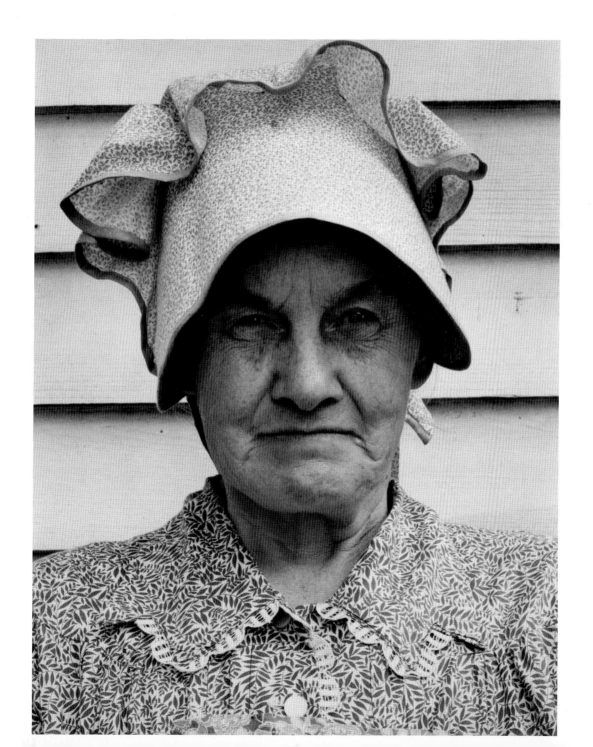

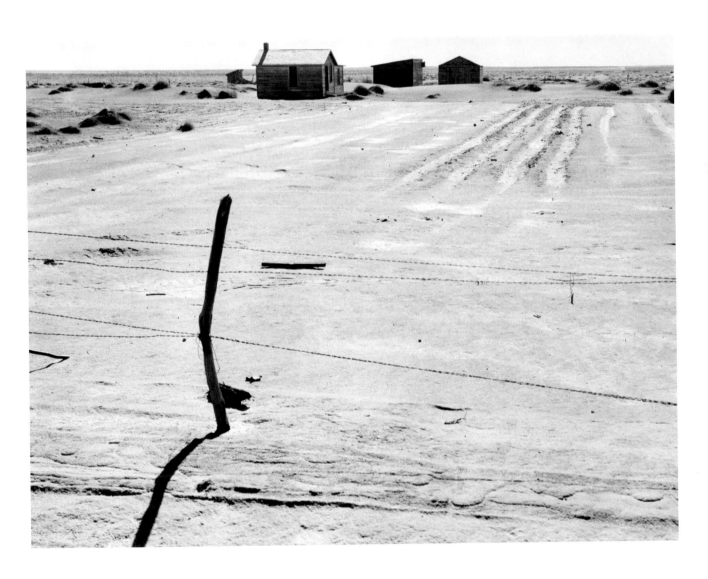

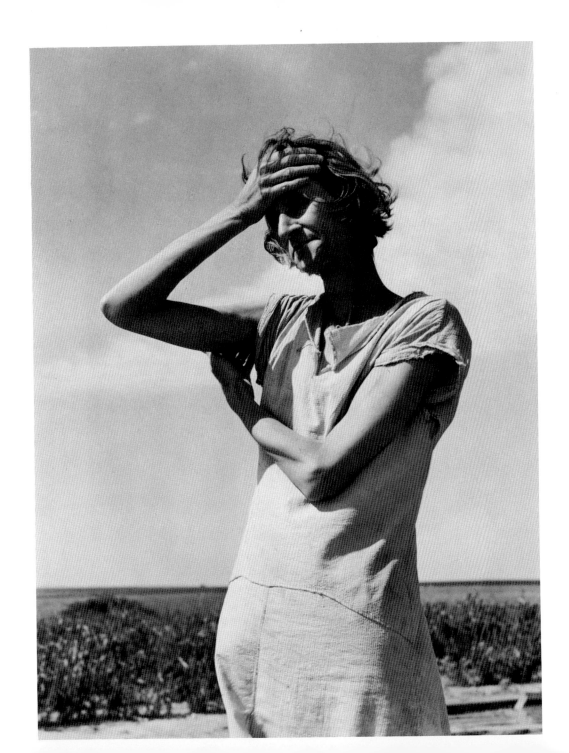

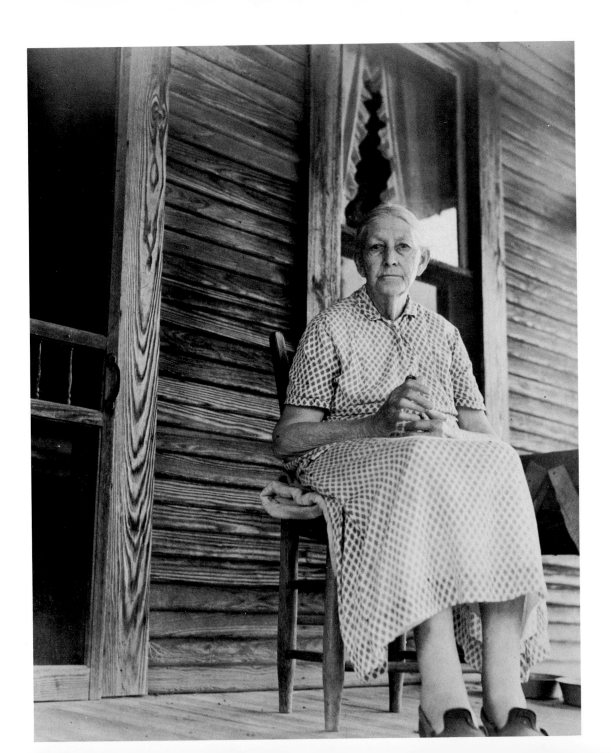

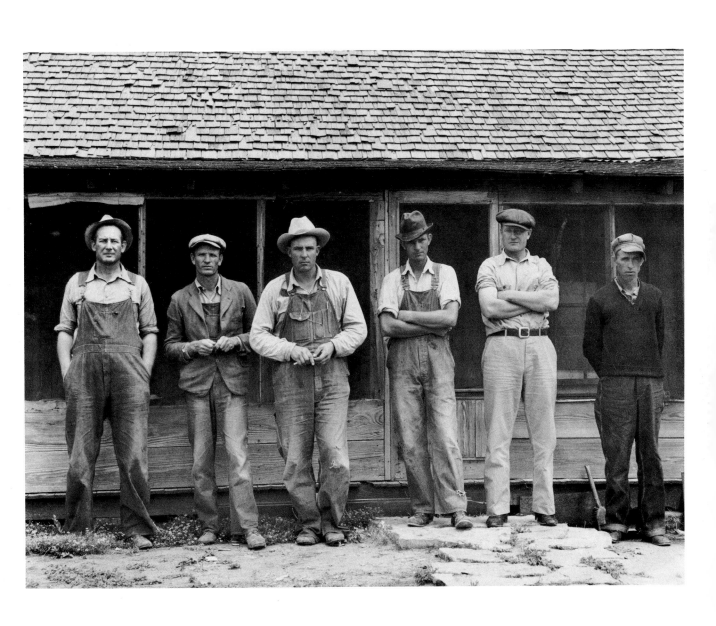

49

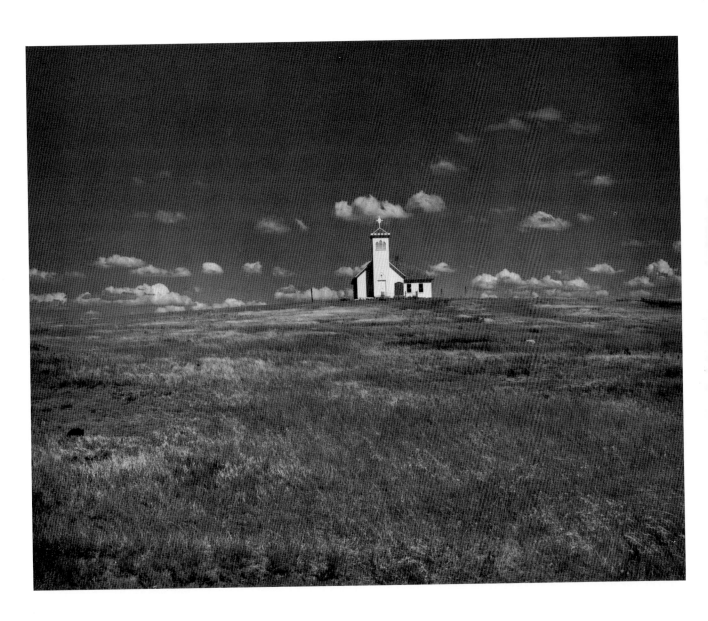

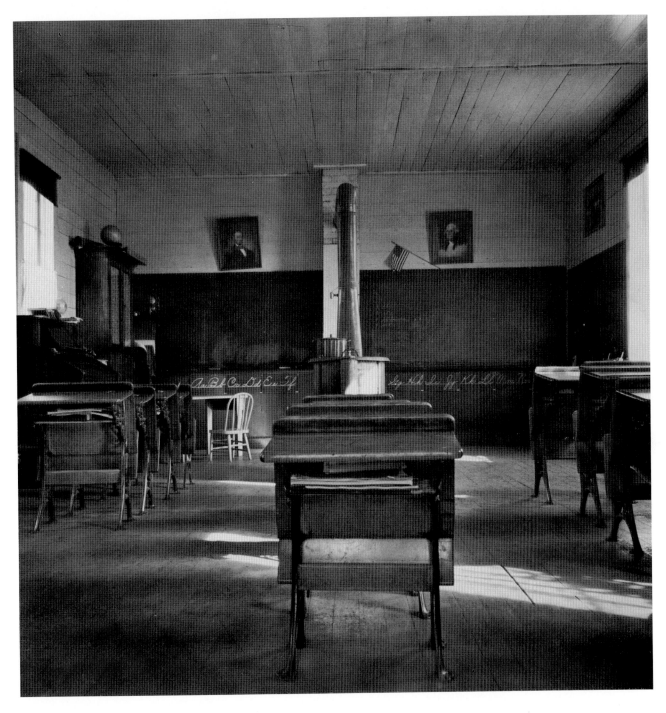

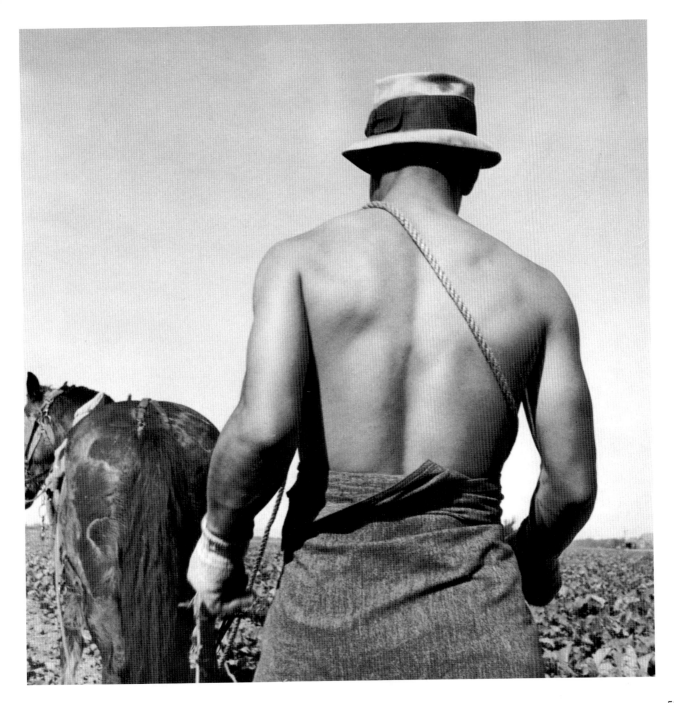

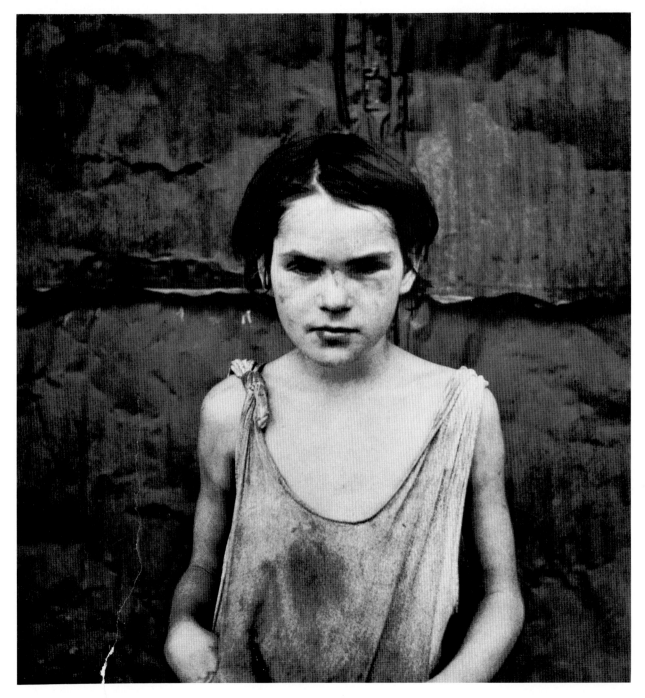

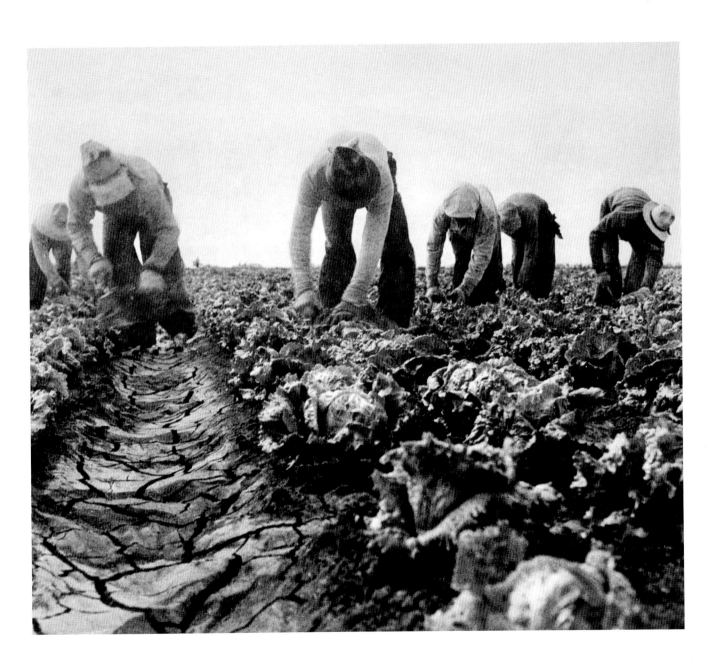

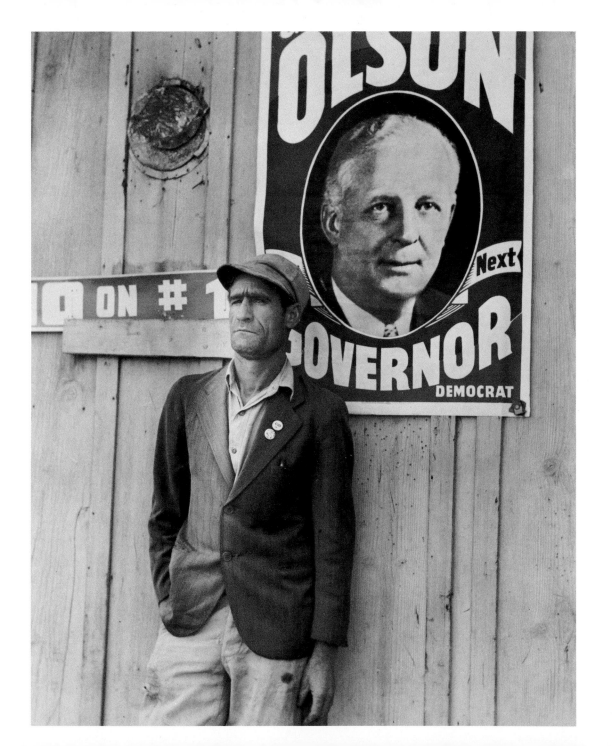

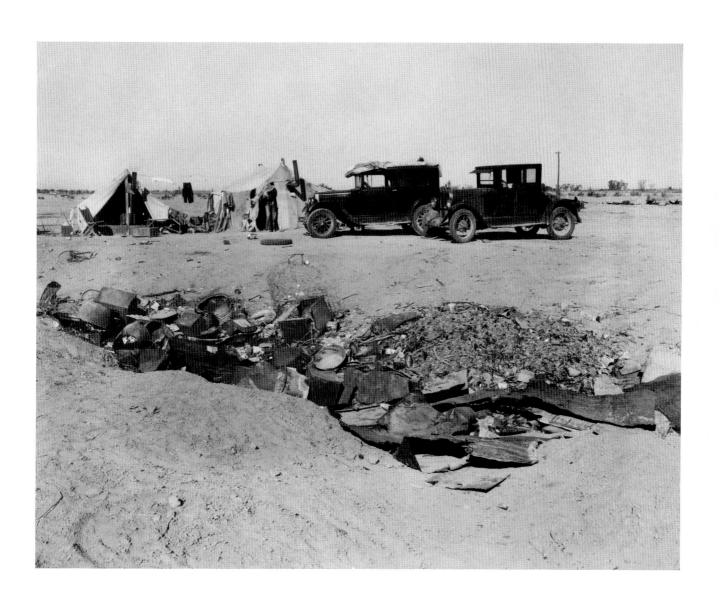

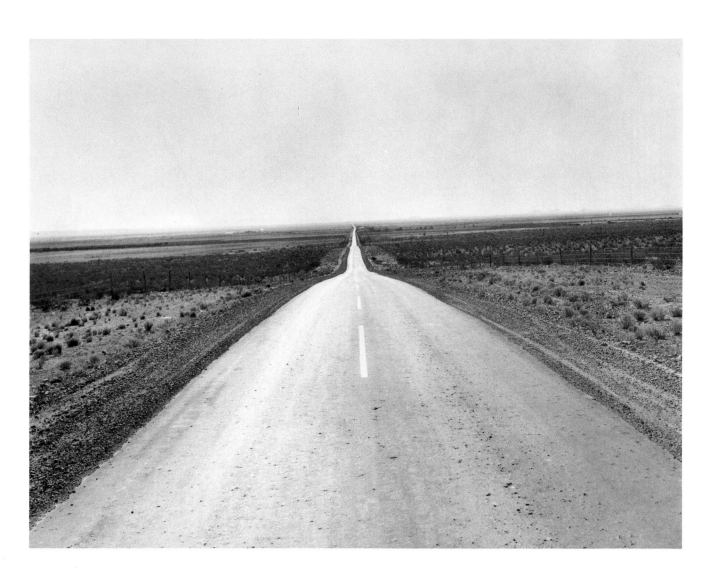

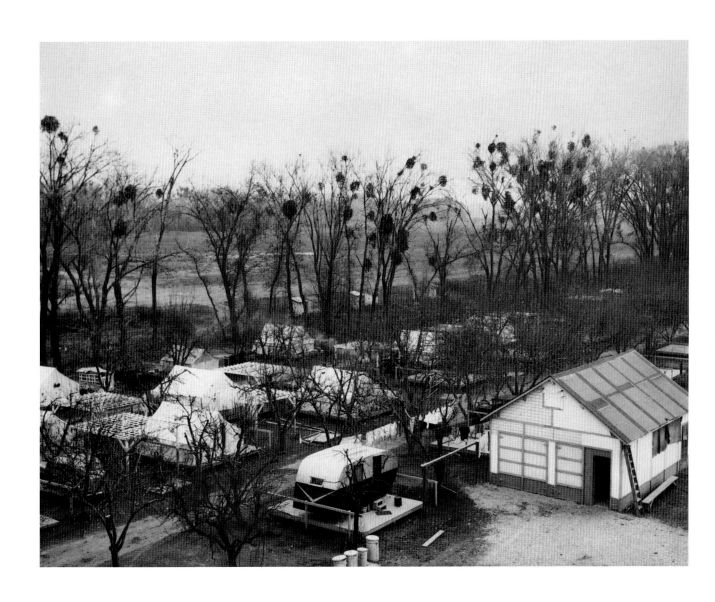

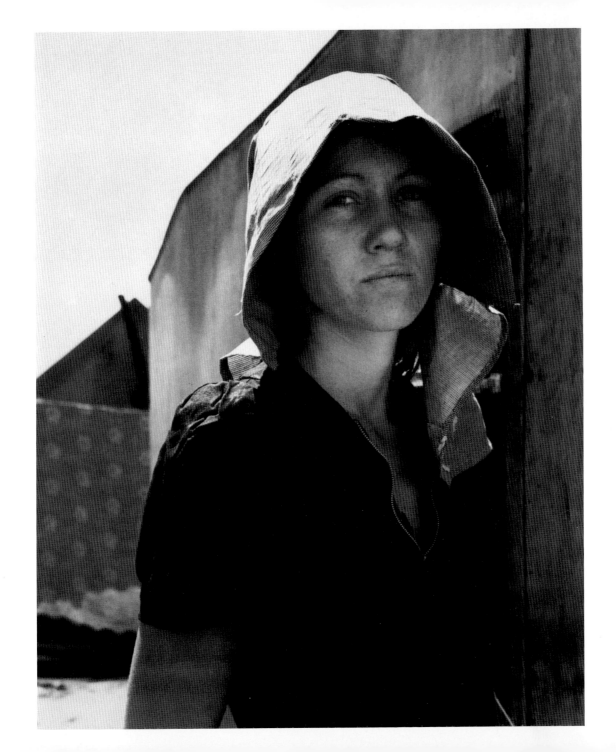

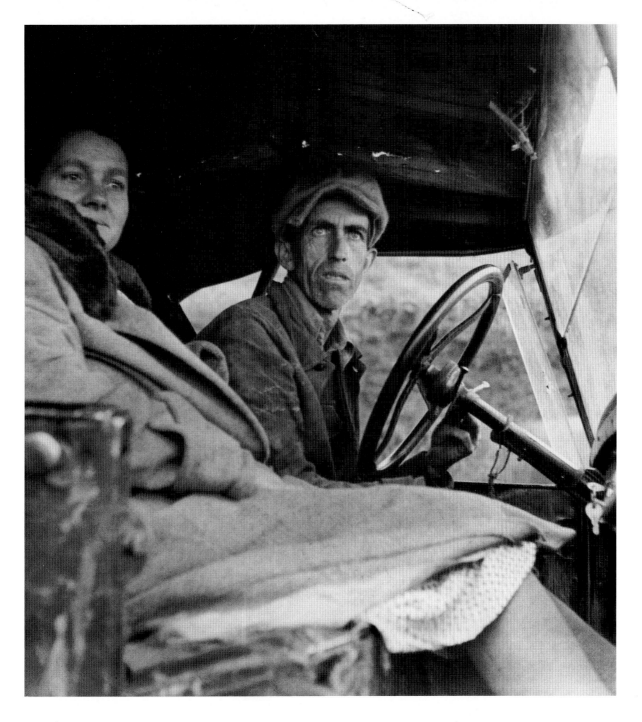

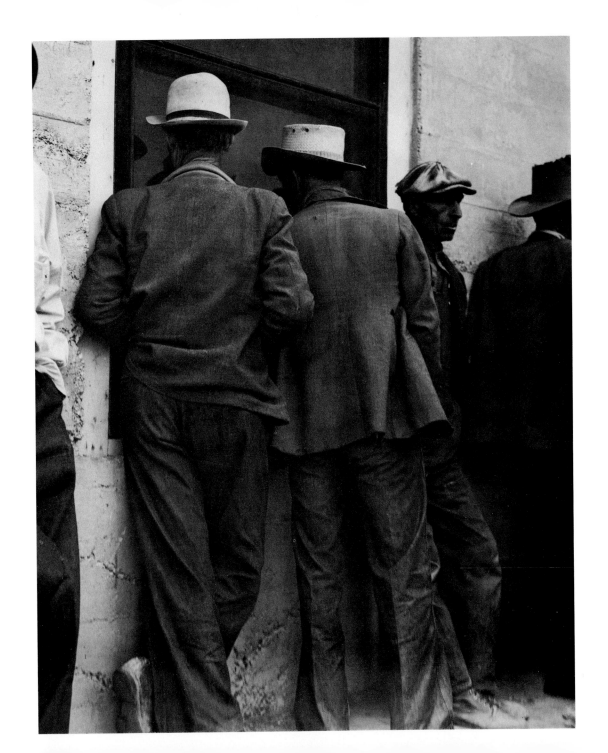

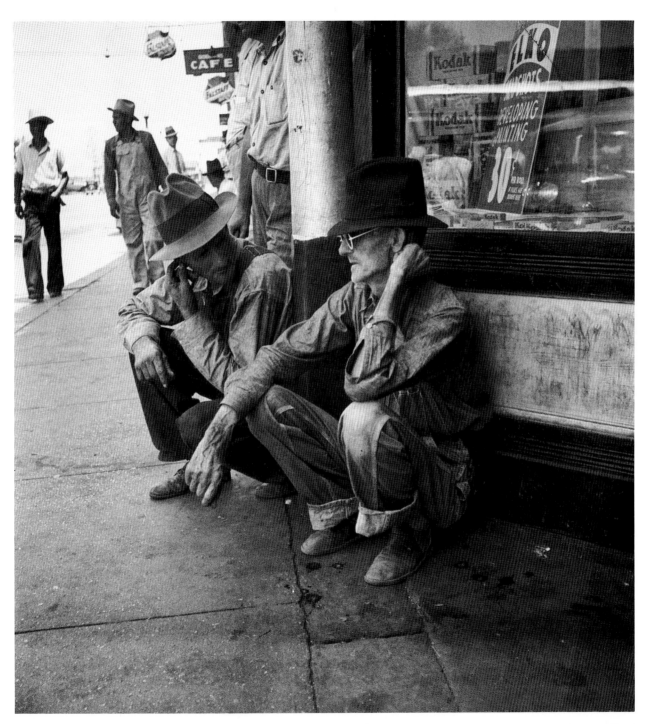

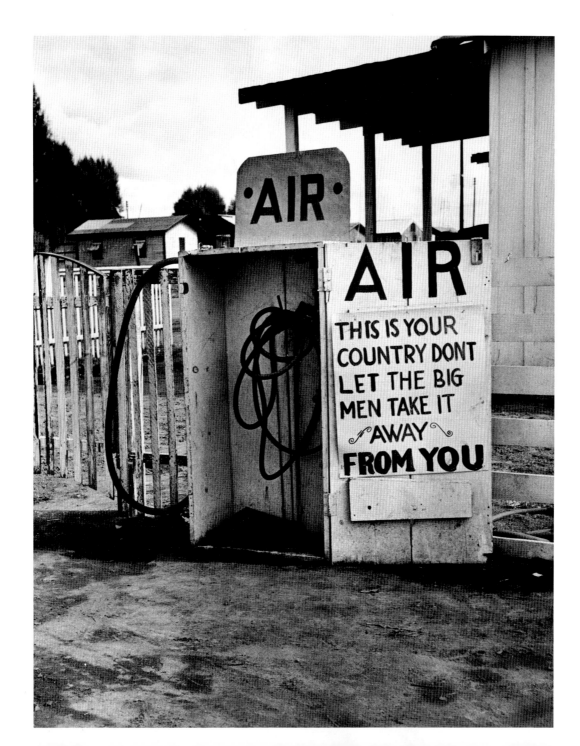

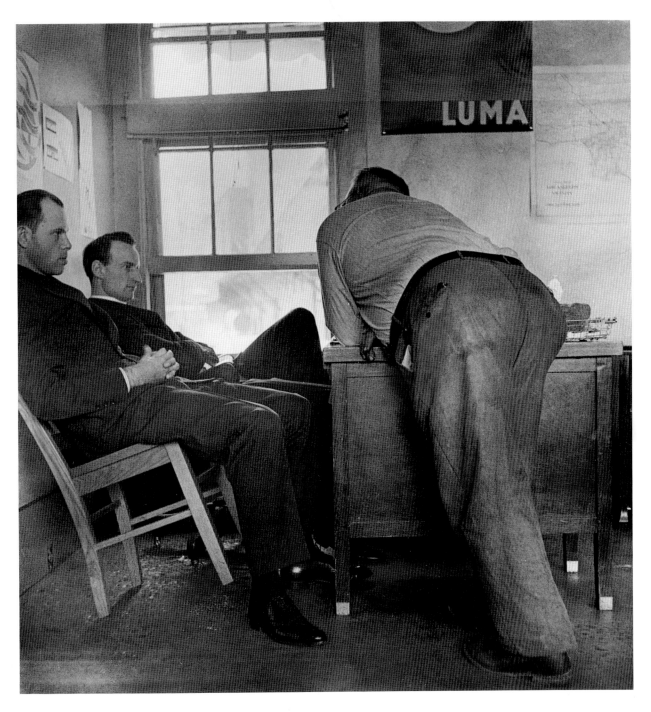

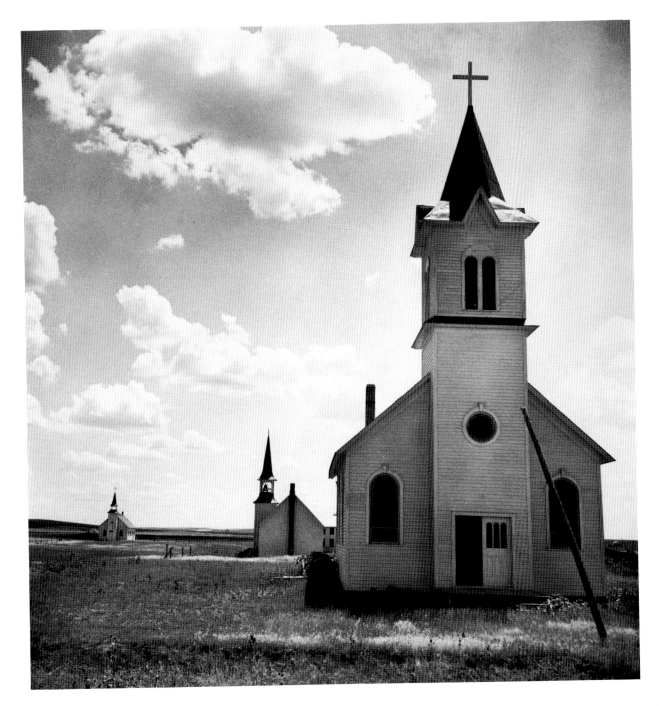

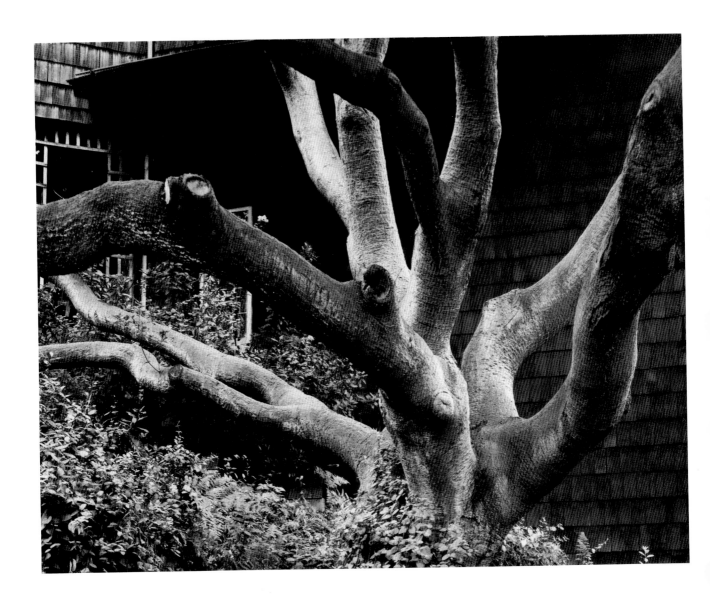

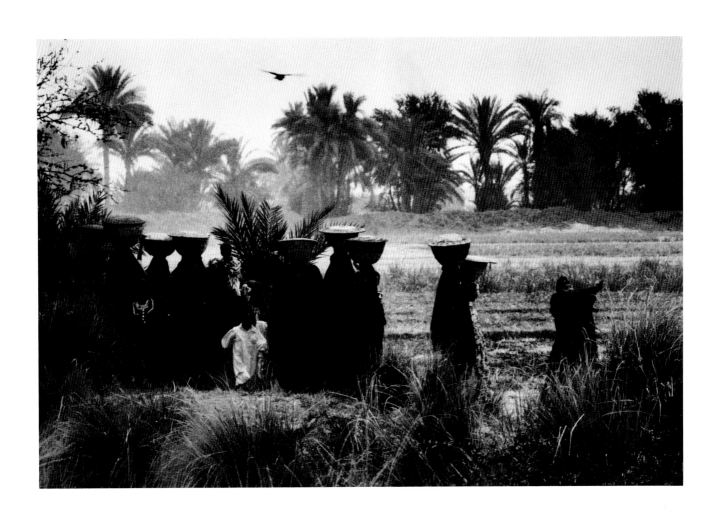

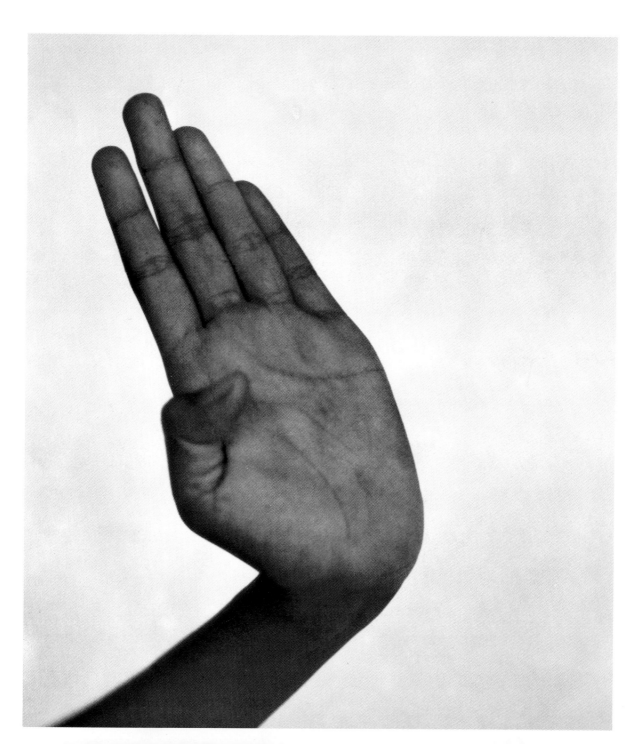

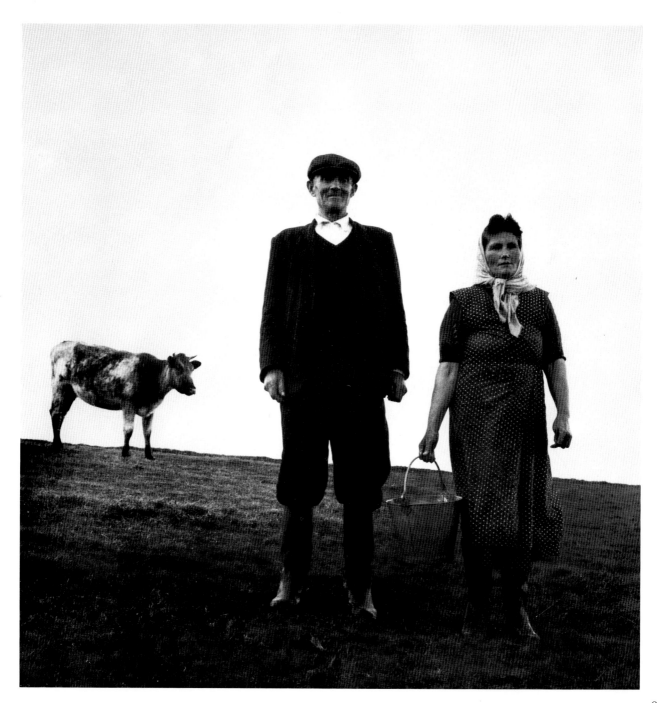

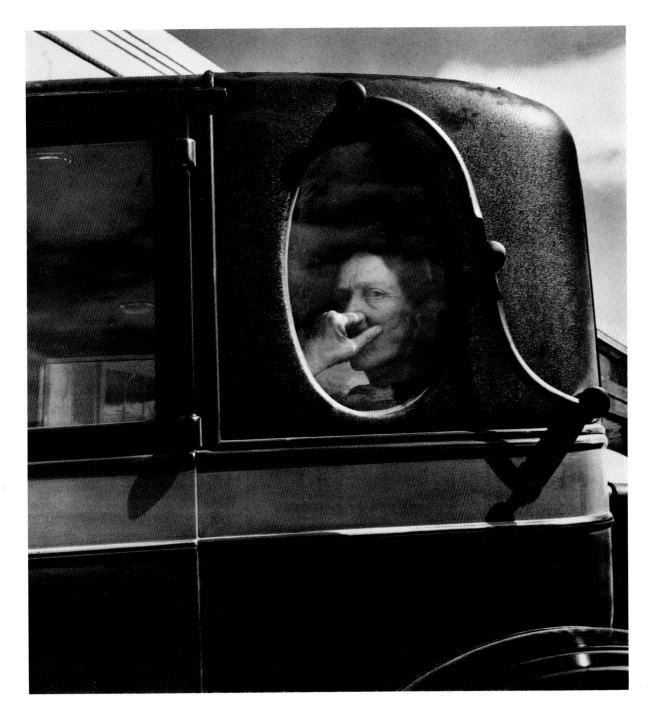

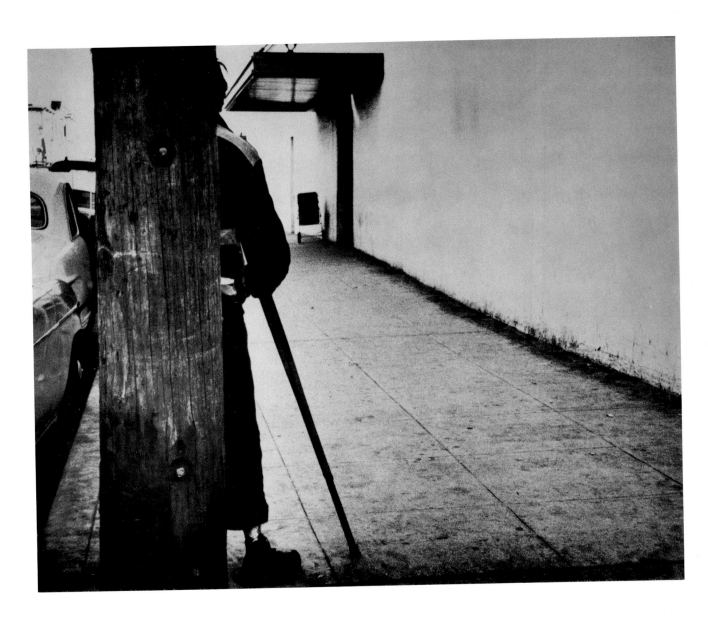

PHOTOGRAPHS

BRIEF CHRONOLOGY

1895 Born in Hoboken, New Jersey.

1913 Graduates from high school. Starts training to be a teacher. Decides instead on career in photography.

1914 Works nights and weekends in portrait studio of Arnold Genthe in New York.

1917 Studies with Clarence H. White at Columbia University.

1918 Moves to San Francisco, where she meets Imogen Cunningham and Roi Partridge. Joins San Francisco Camera Club.

1919 Opens her own portrait studio.

1920 Marries painter Maynard Dixon.

1925 Daniel Dixon born.

1928 John Dixon born.

1929 On vacation in northern California attempts landscape photography but decides to concentrate on people. Stock market crashes.

1931 During early years of the Depression, visits Taos, New Mexico, where she is indirectly influenced by Paul Strand.

1933 Takes photographs of the Depression, maritime strikes, May Day demonstrations.

1934 First show at Willard Van Dyke's gallery in Oakland, California. Meets Paul Taylor and begins to do field work for government programs.

1935–1939 Divorces Dixon and marries Taylor. Works as photographer for Farm Security Administration.

1939 Publication of *An American Exodus*.

1942 Photographs relocation of Japanese-Americans in internment camps.

1945 Photographs founding of the United Nations in San Francisco. Illness intervenes, and she works little over the next nine years.

1958 Travels with Taylor to Asia, South America, Africa, and Europe.

1960–1964 Plans new projects. Completes book *The American Country Woman*. Concentrates on photographing the "close at hand"—family and home.

1965 When she learns she has inoperable cancer, puts aside work to select photographs for retrospective exhibition at The Museum of Modern Art.

1966 Dies in California.

SELECTED BIBLIOGRAPHY

Heyman, Therese Thau, *Celebrating a Collection: The Work of Dorothea Lange*. Oakland, California: The Oakland Museum, 1978.

Dorothea Lange Farm Security Administration Photographs, 1935–1939, Volume I. Glencoe, Illinois: The Text-Fiche Press, 1980.

Dorothea Lange Farm Security Administration Photographs, 1935–1939, Volume II. Glencoe, Illinois: The Text-Fiche Press, 1980.

Meltzer, Milton, *Dorothea Lange: A Photographer's Life*. New York: Farrar, Straus, Giroux, 1978.

Ohrn, Karin Becker, *Dorothea Lange and the Documentary Tradition*. Baton Rouge, Louisiana: Louisiana State University Press, 1980.